The ANIMATION STUDENT'S HANDBOOK

by **Tony White**

Copyright © 2023 HIPPYDIPPYGURU

All rights reserved. This book or any portion thereof may not be reproduced or used in any manner whatsoever without the express written permission of the publisher except for the use of brief quotations in a book review or scholarly journal.

All rights reserved.

ISBN: 979-8-9897425-0-9

Dedication

This book is dedicated to anyone taking those first few steps towards becoming an animation master!

Introduction:

When I first began my career in animation it was a very different world to what it is today. Very few (if any?) art schools offered animation as a subject of learning and getting a degree in this subject was not in any shape or form the primary means of securing a job in the industry. It was solely your talent that got you through! Even now, despite the huge proliferation of schools that offer every kind of animation course around the world, it is still mainly your art skills that will land you a job, not always the *degree* you get when graduating from college! The industry is looking for unique talent that separates you from the rest, plus a personality that will blend into a team-based environment. Tech and tool skills too are important. But fundamentally, it is what makes you unique and special, creatively, which will catch the eye of employers. Your continued survival within the industry, once in, will also be dictated by how talented you are, as well as how successful you network through the challenging waters of that industry too. I believe this book will give you great insights into all of these things - and more! I cannot of course guarantee you will get that perfect job from reading this book. But I can lay the groundwork for you, for success, when that unique opportunity finally comes.

Table of Contents

1 BACK IN MY DAY: ... 3

2 PENCILS OR PIXELS? FILM, WEB OR GAMES? .. 11

3 HOW THE INDUSTRY WORKS 19

Internships = jobs! ... 19

Every day you need to be awesome! 25

4 THE IDEAL SHOWCASING OF YOUR WORK 31

Throwing the baby out with the bathwater! 32

Make sure you show them what they want! 33

Have a sketchbook or a drawing portfolio 34

Quality over quantity: .. 38

Tailor your selections: .. 38

Packaging is all-important: .. 39

5 GENERAL CONSIDERATIONS 53

Avoid bad work! ... 53

Be consistent with all your material: 54

One man's beat is another man's poison: 55

Keep it light. Keep it positive! 56

Keep is short! Keep it smart! .. 57

Be original: .. 57

Personal qualities: ... 59

The good and the bad sides of student work: *59*

6 SUGGESTED ASSIGNMENTS *61*

7 THE IDEAL COLLEGE .. *65*

YEAR 1: .. *75*

YEAR 2: .. *76*

YEAR 3: .. *77*

YEAR 4: .. *78*

8 ANIMATION WORKOUT *81*

9 A FOOT IN THE DOOR *89*

Finding the Jobs: ... *90*

Learn to be patient. ... *91*

The Reality Check: ... *91*

Networking: .. *93*

Cold calling: ... *95*

Recruitment Officers: ... *98*

The Right Stuff: ... *99*

Self-presentation: .. *102*

10 PERSONAL BRANDING *105*

Business Cards: ... *105*

Resume: ... *107*

11 FINAL THOUGHTS *111*

Tony's books: ... *115*

1 BACK IN MY DAY:

When I entered the industry, the apprenticeship system was always the normal way of learning. It remained so until a few decades ago. But then it disappeared. So students, and the industry, are all the worse for it!

At the time of writing I know of no studio that offers any apprenticeship opportunities – although this is by far and away the best way to be prepared for the industry. In my day, and long before that even, most young, and enthusiastic hopefuls could ONLY find a way into a studio via a menial apprentice-style job, such as a runner or a gofer for example. Once into the industry, they could then slowly work their way up through the studio hierarchy, to reach the position they most desired. This process was hard and often long-term, but it

did at least guarantee they were trained well and groomed entirely under the watchful eye of an established and knowledgeable professional. They made sure that their young apprentices were genuinely ready for a higher position in the pecking order when the time came. To be totally honest, the apprenticeship system still remains the finest way of learning. But animation studios today do not think long-term anymore. So, the practice has died away. However, I don't believe the industry is any better because of the loss of the apprenticeship system – it's quite the opposite in fact!

As a result of this loss, young and aspiring animation students now must turn their attentions to animation schools and colleges instead, if they want to be trained for the industry. However, the challenge for most students today is that most schools and colleges teaching animation demand a high price for their tuition – and other than the very best, many do not train their students in the same way that a professional would their apprentice. Standards vary significantly. So, it is very difficult for prospective students – or rather their parents, who usually pay for their child's education – to know how to choose a good school and whether their child is getting value for money with their education, or not.

In many cases, when students or parents eventually realize they've made a mistake in the right choice of school, they have probably already invested heavily to ensure their child is educated well. Sometimes, even if a student tries to move to another college, mid-course, they suddenly find that the credits they've already earned at the first school are not transferable to a second school. As a result, the student remains stuck in a poor program, with a huge and increasing student loan burdening them, or their parents. Consequently, they have no choice but to stick it out to the bitter end! The next big shock, however, comes when they graduate and find that they have not been trained adequately enough to get even a menial job in the industry! This is not true for all schools and colleges of animation – but it is so for more than we care to admit.

Another problem with so many schools is that they have a tendency to follow trends, rather than pioneer them. For example, up until the early 1990's an education in animation was entirely based on the traditional principles of art, drawing, color, anatomy, perspective and a number of other foundational art courses. However with the advent of desktop CG animation technology – and now AI - the notion that art skills are essential, or even valuable, has tended to fade away. As a result, so many schools have ditched classical art training entirely, preferring

instead to jump blindly onto the software and tech bandwagon. Yet, even with the miracles that modern technology can offer, it must always be remembered that that same technology is still only a tool - and that unless you have the artistic and creative skills to bring to that tool, the output will be underwhelming or predictable to say the least!

The one thing that any prospective student in animation must accept from the get-go, is the fact that with so many schools and colleges teaching animation today, the graduates who really make it in the industry must stand out in some way. I was once told by a recruiter at Pixar for example, many years ago, that they see thousands of graduate applications every year. But, in truth, most of these are barely glanced at. This is because they noted that everything tended to look the same, no matter who they were or what school they came from. This is because all colleges teach the basic software and generic movements with that software. Yet, few colleges teach students to be artists anymore. They focus on them being software operators. Consequently, when somebody with the required technical skills, PLUS art skills, and sketch books, and creative artwork that is just beyond the usual animation art, then they tend to take a lot more notice. Indeed, that recruiter confided in me, saying that if a young kid comes through their door with

nothing but stick-figure, drawn animation only, and with no technical skills - yet their animation moves beautifully – then they will snap up that kid immediately! The rationale here is that anyone can learn software, but few have the artistry and the sensitivity to pull off character animation beautifully.

So, students with a training in traditional art skills – including "figure drawing", "shape", "form", "color theory", "anatomy", "perspective", "dynamic pose" and "light, volume & shadow" - will have a much better chance of getting ahead of the crowd when applying for work. This will be no less so in the AI era, even though the current spin says it will make artists redundant. I remember a time, way back, when we were told that computers would make our work so much faster and easier that we would have much more time for leisure in the future. And we've all seen how that one worked out, haven't we! Suffice it to say, trust someone who has been at the top end of animation and teaching, when I say that what is said never turns out that way. In the AI future we are all facing right now, it will be the art-trained talents that will win out in the end. Because, if anyone can do it, how are you going to stand out as being special, which is what employers will always want when recruiting.

Students around the world are constantly asking me questions concerning them entering the industry. So, I have become quite expert and predictable when I answer them – especially on the issue of art skills. This is so much different from the time when I first graduated from college. There were so many creative jobs and few schools or colleges teaching the right stuff. If you could land an apprenticeship, as I did, you were guaranteed of finding a job for life – or at least, for a time long enough to pay off your student loans. And even if you couldn't land an apprenticeship, the odds were pretty much in your favor that you would find some kind of worthy job, regardless. But finding a job in this overcrowded, digital, day and age will require much more guile, persistence, and talent of a unique nature. Long-term jobs are pretty much a thing of the past these days, with limited time "contract" work being more the norm. And even if you manage to find some work eventually, your successes will be more a question of being in the right place at the right time! That is, unless you can show skills that put you ahead of the rest, which is where classical art training comes in.

With all that said, there are still a great number of things that a student of today should be aware of before they begin that journey to their dream job in animation. This book will cover all those bases for

you, and at least prepare you well for your future career journey. At the same time, never forget the advice I once heard a seasoned professional giving his prospective students… "Once it was hard finding a door to even enter this industry. Now it's almost impossible to get through that door, should you find it, with so many others trying to get through it with you!"

2 PENCILS OR PIXELS? FILM, WEB OR GAMES?

It is probable that you are reading this book as someone who is considering going to an animation school or college, as part one of a bigger career plan that will enable you to enter the animation industry as part of a career dream. If so, bravo to you! We won't address specifically what part of the animation industry you're most interested in, just deal with the industry in general. This will give you and idea of what to expect from the animation world in general, and what it will entail to get an animation job once you've graduated. Then, we'll cover the college side of things – namely, focusing on how to get into college, how to choose a college and what to expect once you're in one. Does that sound like a plan? If so, let's go…

So much has changed in the industry over the past decade or two – and that change is happening faster and faster, in the technology at least! So much so, that what is true today, may not be true tomorrow. However, based upon my extensive experience of animation and teaching, over many decades, I would still say that if students continue to add time-honored art skills to their tech knowledge, then they will have much more chance of surviving in a very competitive industry. It doesn't mean that you must be a great artist to succeed in animation today. But it does mean that you'll need to have a solid understanding of the core principles of art, as well as an "animator's eye" for observation. This all needs to be tied to an ability to express what you see through sketching it out if nothing else. Great ideas and great concepts often begin by being drawn on the back of an envelope, or sketched onto a napkin in a restaurant, and that should never be forgotten!

It is, of course, very tempting to buy into the myth that technology, not art skills, will be the future of the industry. However, I think the student of today will buy into those notions at their peril. Even with the extended presence of computer-based, CG or 3D animation being present in the industry for some time now, there is no doubt that the most successful and the most respected of animators today still have some kind of art skills added to their technical or

software skills. One look at their social media posts of top animators, or their personal websites, will reveal that so many of them continue their passion for art or creative work outside of their day job.

As a young, aspiring animator in the making, it will pay you to begin your career journey with eyes wide open. Self-evaluation at this stage is of paramount importance, as certainly be a great amount of that, from others, when you enter the industry. It is all well and good thinking that you love drawing, you love playing video games, or you would love making the kind of animated movies that you grew up with as a kid. But career success is not as simple as that. There's an incredibly large amount of hard work ahead of you, far beyond it just being fun thing to do. Alternatively, you shouldn't think that just because you maybe don't draw well you can never be an animator. This is not a correct assessment either – but again, if you are going to make it so, then it's going to require a great deal of hard work for you to get there.

The truth of job success (and survival beyond the first job) is that if you draw from observation, can demonstrate strong classic art skills, AND are conversant with current software, you will be ahead of your rivals for both college and industry entry.

Recruiters of all kinds consider it a premium if a person has more arrows to their bow than the standard school or college graduate. A talented digital artist that can also demonstrate traditional art skills and knowledge is still pretty much a rarity – and more so with contemporary educational entities focusing on technology rather than art – making anyone who has skills in both a much more valued commodity. A digital artist/animator who can show a talent for color, perspective, anatomy, and not just software skills, is a far better resource for colleges and studios than a mere technician.

As I say, demonstrating a 'complete artist' skillset will not only put you ahead of your competition in in any applications you may make, but it will also offer you a wider career potential in the longer term too. So, it is essential to build on your additional skills now, to demonstrate your worth.

Most of the best employers within the industry are quite discerning. They know full well that most of the animation schools and colleges out there, are guaranteed to more or less teach all the basic digital skills in terms of software. However, what they are always looking for, above and beyond this, are applicants that can show that extra 'something' beyond the obvious. So they are searching further

and further afield – i.e. even abroad - to find that special kind of applicant. This is no different for animation school or college recruiters, as they have their own reputations to protect and they work on the old principle of "garbage in, garbage out/quality in, quality out". They want the best student applicants they can get their hands on, as they know this will ensure that their graduates are the best too. Consequently, it is important that you make yourself the best, by enhancing your core skills across the board, in order you attract their interest – whether 'they' be in education or the industry.

It goes without saying that the versatile student graduate will always find a place in the industry across the board. Animation jobs are invariably of the contract type, with most animators and artists moving from job-to-job, studio-to-studio, contract-to-contract - and even location-to-location - to find employment consistency. The very top animation studios are usually only looking for specialists – that is, applications who are really good at one thing only. But most of the mid to small size studios are much more interested in those with strong, across-the-board art and animation skills, as they can assign them to various positions in the production line, when and as the time comes. Consequently, unless you are a particular genius at any one specialty, it pays you much more to prepare yourself as a

generalist, to assure yourself of continuity of employment.

Research is essential, even from the outset of you seeking a career path in animation. Know what area of animation you want to go into. Know the kind of studies there are out there, and what kind of artists they are invariably looking for. Then begin to train yourself to cater for that need – even if you're not enrolled in any college animation course yet. Industry skills and requirements will change, as does technology. However, the one guarantee is that the top generalist, across-the-board, artists out there will always be the ones who will win out. The bottom line here is that you need to understand your market and develop the skills that it is looking for – even if that forces you out of your comfort zone at times. As a result, you should also put into your portfolio or showreel the things that your target college or studio will most want to see. 'Passion' too is what often sells a recruiter when hiring someone – so make sure that if you're are able to get an interview, you are enthusiastic for your work for them, and for the way you can grow by working and learning from them. Being distant, arrogant, or simple "cool" will guarantee that you'll never be what you're looking for. Unless of course, the folks you're pitching to are looking for that type of attitude from an employee in the first place! (Which some – albeit

very few – do.) But again, research who you're presenting to, what they want, and what they do in general!

It is not at all usual for most first-time college or job seekers will not find what they're looking for first time around. In that case, you'll have to consider a 'Plan B' – or even a 'Plan C' or 'Plan Z' in some circumstances! Perhaps the most important thing to keep in mind here, is for you to get SOMETHING, SOMEWHERE as soon as you can! This is important. Once you get in somewhere, you can always begin to actively network and maneuver yourself, until you find that perfect position you ultimately dream of elsewhere. The key is that you do need to start somewhere. So, go where you're most appreciated and move on in a more leisurely way later. It is all certainly a question of stealth and patience when seeking the ideal career path for yourself. Very few individuals hit a home run on their first interview – and often, that is a question of being in the right place at the right time. So, consider your options, your alternatives, and your tactics, or where you want to ultimately be – even if it takes you time to do that. Picking the right college for the right career path in life is fundamentally important to all this, of course.

3 HOW THE INDUSTRY WORKS

Before you begin your job search you should at least know the way the industry works and the options you'll have on your journey through it. Here are some of the things you need to know.

Internships = jobs!

With the absence of an apprenticeship system, one of the few ways of a student getting into the animation industry is through an internship. Internships can be rare however, for many - but the most common of them occur when a studio is rushing to ship a new project into the marketplace and they desperately need additional help ('grunt labor') to get things done. In such a situation the

studio may even approach a nearby school or college and select their best students to help out on the production. It's not common, but it does happen. This can sometimes be for no money, or in other cases, for very little money. Some students complain, feeling this is 'slave labor' – which it is, in some ways. But in reality, it is a major step forward for your career. Remember, the hardest thing for a new college graduate to offer a prospective employer is "industry experience". It is a HUGE challenge for even the most talented of graduates. So, an internship of some sort will give a graduate some of that illusive industry experience. Also, many individuals who excel in internships tend to get this extended to a part-time, or full-time, paid position down the line.

As indicated above, *industry experience* is the one thing that even the most talented of all new student animators cannot easily offer. Studios working to a tight deadline, or just trying to establish and maintain high standards in their project work, are reluctant to take on anyone who is new and untried. Consequently, no matter how unfair it seems, studios instinctively go for someone who has anything from 2-5 years industry experience of the industry in question. This seems somewhat unfair on emerging newcomers, and it is certainly not an easy challenge to get around. But it has to be

recognized that studios will always instinctively take a safe route in these things, so they'll always go for someone who has 'been there, done it' first. This can be true, no matter how amazingly talented a student animator might be. This does of course raise the age-old frustration that all first time job applicants have to suffer – 'I can't get a job because I don't have industry experience, but I can't get industry experience because I can't get a job!'

There's no easy solution to this unfortunately. Every animator somehow finds his or her way into the system eventually and rarely the way they achieve this is the same, or even predictable. Yet, there are definitely methods to employ that will keep the pressure on. Even though you will need to keep your fingers crossed that you also have that all-too-illusive quality that most job seekers need - the good luck of being 'in the right place at the right time'! Remember, if someone asks you to do just menial tasks - such as being a gopher, washing up or sweeping the floor - don't complain about it. Instead, do the very best job you can as this will mark you as an individual who excels at whenever they are asked to do!

Networking:

There is one valuable way of attempting to get around the work experience challenge - although that too is not easy, especially if you're of a shy or introvert personality. It is called 'networking'. Networking simply means that you attempt to meet and mix with as many industry people as you can, in the hope that they will like you and therefore want to know more about you and your work. Consequently, if they like what they see, they will recommend you to others. It's amazing how many jobs (and careers) start in this way! The animation industry is a small yet close-knit community, so everything is known and shared quite quickly and openly. That is why networking is so important to you in your job search.

Networking needs to begin at your animation school if you're still a student. All those contemporaries of yours who you see day after day in your classes could well be the same individuals who might be in a position to offer you a job further down the line. It may seem a strange thing to say but I have seen this happen many times. There are always one or two students in any graduation cohort that seem to somehow slip into a job without any trouble whatsoever. (And sometimes these can actually be students you think will never, ever easily get a job!) But then, a few months later when some of their classmates are still looking for work, as must be

expected, they are suddenly in a position of recommending someone for a new position that opens up where they are. Of course when in this position individuals will tend to go for others they best know and trust, as their job could be on the line too if they get it wrong! So to protect their own backs they will pick someone well known to them. Who better than an old school colleague they knew and liked when they were studying at school?

Therefore, the message here is to get on with EVERYONE in your class and at your school when still a student – yes, even students you're not so keen on! You just never know who will be in a position to hire you further down the line. So, cover all your options. Nurture your friendships – and make them genuine friendships, not just the 'user' kind. It will definitely pay off in the long run. (And should you be the one who is doing the hiring in the future, watch how your classmates work, and make mental notes on which of them you would hire and why.) In this way you might find that your job-seeking adventure could start in a very positive way!

Another way of networking is to attend seminars, conferences, events, and even comic book fairs. Then, be prepared for anything. You may never know when that magical moment of *'right place, right*

time' occurs, and you could suddenly be presented with meeting an unanticipated someone who is actually looking for an animator or artist to work in his or her studio. You have to be prepared for such moments. At the very least always keep a business card with you at all times, if your portfolio or showreel is not possible. And if you have a presentable social media account, or two, make sure that link is on your card too. We'll go into all this later, but if that card offers a link to at least your email address, phone number and a website where your work should be on display, you'll have gained an important advantage over everyone else you're competing with, by sharing it around. Additionally, big events can sometimes have portfolio revues, where big game studios or places like Disney and Pixar and the like have a booth or table where prospective employees can stand in line to show their portfolio work. Be warned! These lines can often be filled with many tens, sometimes many hundreds, of other job-seekers who are all anxious to show their work too.

But whatever path you take to get that first job, it will definitely pay you to stick it out - as you never know if you possess that one thing that they're looking at that point in time. Be persistent, positive, and tenacious - although the message here is, be 'insistent' yes, but never 'annoying'!

Every day you need to be awesome!

One thing that's a major feature of the modern contract-based animation world, when you are working, is that most jobs are *cyclical* in nature – and it is therefore important that you always give the very best of what you can offer to the studio you are working for. Except for the comparatively few star artists and animators who are hired full-time in game or film production, most employees are hired within a limited contract system. This means that once the project they are hired to work on is finished, they are invariably released to find work elsewhere. If the studio in question is big and established - and therefore has a greater and more guaranteed turnover of productions - artists can often be re-hired immediately, without a significant break in their employment. But, more usually, contracts have fixed timings attached to them, and so when they're up they're up! Even when an artist or animator is hired, it makes a great deal of sense for them to keep their ear to the ground for upcoming opportunities - yes, even while they're working. If you are one of these workers, you should definitely keep your showreel and portfolio updated and current, just in case you need to make a sudden submission somewhere else, when the opportunity arises.

Wherever you are or whoever you are the industry is a *'feast or famine'* environment – meaning that even the biggest studios experience down times as well as up. In my own personal experience, as an employer, I found that even with my very successful, award-winning studio at my fingertips, we were always looking for work in downtime. So, even though I loathed to let people go, I had to do so on occasions, so that the studio could survive throughout those downtimes as a result. The way to survive the system (i.e. once you're in it) is to excel at what you do, thereby building a strong reputation for yourself in being professional, flexible, achieving deadlines – as well as going over and above the call of duty when required. The second crucial thing you need to do is keep current with the twists and turns within the industry - ESPECIALLY maintaining a network of contacts that can be invaluable for you when you're looking for that next job. It's amazing how your fortunes can turn as a result of a single phone call, made at the right time!

Additionally, it doesn't hurt to have two or three extra strings to your bow. If you only want to do animation, still don't close your mind to other job options, in the interests of survival, as that may just see you through the down times. For example, a traditional 2D animator will presumably have a

significant drawing and designing ability. So pursuing additional work in illustration, cartooning, storyboarding and even comic book/graphic novel drawing could well keep the wolf away from the door for you, between contracts. Sometimes, cherished hobbies can often offer a small income to fall back on if your main source of work dries-up from time to time. So, be versatile, be creative and be mindful of what's going on in the world beyond your own specialty!

Appearance and demeanor:

The animation industry has never been one for suits and ties. Perhaps at the highest levels of executives and marketers, popularly known as 'the suits', you will find more traditional, executive apparel. But, by and large, the artists and animators in the production world dress casually and live their lives less conventionally than most. Even with that said, appearance and demeanor is still very important when you go for an interview for that all-important first job. This doesn't mean that you have to look and behave as if you're attending church or a funeral. It just means that you have to present yourself in such a way that the person interviewing you feels comfortable and not threatened by you being too off-beat, arrogant or just plainly weird.

Remember always, whether you're interviewing or working, a prospective employer will always be assessing you as a person. Animation is a team game and so they will certainly be wondering if you'll be a socially acceptable fit, regardless of your creative ability. Consequently, Mohawk hairdos, scruffy metal or punk T-shirts or dirty skin and hair may not be the best look to impress at an interview – unless of course the studio you're interviewing for is run by punks, or Goths, or Hells Angels. Then, you should probably dress up for the part! This is where it is an absolute priority for you to research the studio you're being interviewed at – i.e. to know what they're like, how they present themselves and what kind of work they do. The more informed you are about them, the more you will impress them – if, that is, you're not too creepy about it!

Generally, you should present yourself to them as clean, casual, neat, and certainly with no dubious odors emerging from your armpits or other bodily parts! Make sure any business cards, resumes and cover letters you give them are also neat, clean and well-designed too. All informational paperwork you present should communicate clearly and easily - and definitely illustrate your understanding of the studio you're applying to and their own individual production process, of possible.

Avoid monosyllabic answers when you talk and be courteous. My grandmother used to tell me that a 'please' and a 'thank you' were free to give, but always got you a long way. I've always found this as sage advice throughout my career! Essentially you want to both blow them away with your work, while at the same time making them very comfortable and trusting of you as an individual. So pay attention to how you appear and how you perform. Additionally, the way you talk to friends and classmates at school or college may not be the way to speak at an interview – at least until later, when you're working with them. All that said though - you absolutely must be yourself. Just make sure that 'yourself' is not something you are faking, as people seem to see through that kind of thing quite quickly! Above all else, be passionate and confident about what you do and what you show. Most studios are extremely keen to hire someone who is not only good at what they've done in the past, but who are also enthusiastic and excited by what they can offer a studio in the future too! Finally, appear smart and informed about things. But an arrogant, or 'know it all', attitude will almost certainly offend others, and will definitely NOT get you hired in the final analysis!

4 THE IDEAL SHOWCASING OF YOUR WORK

Now it's time to consider the dos and don'ts of presenting your work. This is important for any creative job, but especially in the animation industry.

You are only as good as the work you show and you must never forget that. Your work has to be accomplished and have quality. It needs to be imaginative yet it has to be relevant. It also has to answer the needs of what studios are currently looking for, yet it has to be unique and versatile too! Mostly, studios are looking for that one person who is good at everything and can bring something different to their party on top of that.

Throwing the baby out with the bathwater!

It is very true that we're living in a fast-changing, ever-evolving technical revolution and certainly no modern job seeker in the animation industry should ignore this. Their work has to reflect what is current and what is required. However, simply knowing software will just not cut it anymore. This may well have been true in the earlier years of the digital revolution, but it is certainly not true today. Low level animation jobs will probably still accept those solely possessing a technological bent, but the further up the totem pole you go the more you'll need to add to your skill set – specifically in your art, drawing and design skills.

If you need confirmation of this, check out the web and social media sites of the top movers and shakers in the business. There you will see they proudly present their artistic accomplishments that lie beyond just animation. They may be talented graphic artists, cartoonists, painters, sculptors, graphic designers in their own right - and most of those have done that by having solid drawing skills too. Observational gesture drawings, and life drawings, will be part of their foundational work too. Consequently, studios will recognize good and

well-rounded talent when they see it - and very often, these multi-tasking creative people are the ones who make well make the hiring decisions for the studios too!

Make sure you show them what they want!

Before you pitch your portfolio and/or showreel to any employer, make sure you know first what they do and what they want. If that is reflected in your material, then you will clearly have a better chance of landing a job with them. Filtering your work beforehand is something you should do if you can. Remember also that a number of the smaller studios will tend to put a greater emphasis on 'versatility' in terms of the talent then are looking for. So, in those situations, make sure your work is diverse and reflective of their style of operation. Animation work alone, however good it might be, may not be enough for them to hire you in those circumstances. Often an animator is required to show a much broader portfolio of drawings and other art or design skills beyond their showreel. Technical skills are clearly important. But, if employers see real creative talent in you, they will certainly be prepared to train you in whatever technology they need you to work with. You won't be required to know every piece of software that's out there, although if you're

conversant with the main ones, then that will go a long way. Art talent and a willing enthusiasm to learn, can often override any lack of expertise on the technology side you might be missing.

Again, I can only repeat, when economic times are challenging, most mid-to-small studios will tend to favor solid all-rounders that they can count on, rather than the genius who is good at only one thing. Evidence of a competency in more than just animation work will definitely be a bonus in many cases. Additionally, 3D/CG animators with a 2D track record are especially desirable, as it gives the studio more flexibility in what they can offer clients – and often, someone who is good at 2D will invariably be good at 3D, given a basic knowledge of the software. Whatever you do however, show only your best work, even if it means you cut down on the amount you show. You should definitely NEVER show substandard work, even if you have a good reason for it being so. Sad as it may seem, you will ultimately only be judged by the bad things you show, not the good!

Have a sketchbook or a drawing portfolio

Today the very best animators are not simply software jockeys. They are invariably seen as artists

in their own right, who just happen to be good at animation too. For example, many of the top Pixar animators who have been there from the earliest days of the studio, were originally traditional, hand-drawn animators who were trained to work in a 3D/CG platform, and it really shows! Classically trained artists – as opposed to just technical animators or software engineers – will always make better aesthetic decisions too. This is why the most astute (and therefore best to work for) employers are increasingly catching on to this, in terms of what a more artistically creative employee can offer them. Invariably TV, film and games productions are produced under great time and money pressures. So, it is better for a studio to have an employee they can switch around in the heat of battle – from one place in the production line to another - when the crunch happens.

Some studios feel that drawing is so important to their artists, that they actually encourage weekly life or observational gesture drawing classes for their employees. Pixar even have an internal university for their staff, where anyone can study any art disciplines they like, under the supervision of top people in their respective fields. They know a artistically talented work force is a better workforce when creating top-of-the line work. Therefore, I cannot stress strongly enough the importance of

drawing for a working professional in this very competitive, digital, day and age. Observational drawing, especially, sharpens your skills and your eye as an artist, animator or even a technician! Therefore, always keep a small sketchbook with you wherever you go and draw whenever you can. You'll be amazed by the reaction of some recruiters when they see a sketchbook like this tucked in with your main portfolio – emphasizing to them that you have strong curiosity of the world, but you can also translate what you see to others, through your drawing practices.

Outside of this, take drawing or any other form of art classes with a working professional when you can. Even a solid community college class will do. It's so easy to get into a rut in the industry. So, by extending your reach artistically, you are showing your creative versatility and capability outside of the everyday working norm. In fast-changing and ever evolving the industry that we are all in, it really will be a feather in your cap if you can quickly adapt to any style or approach asked of you, when in a studio environment. Artists who draw well can generally do other creative things well too.

Even if you are a full-time student who's school does not focus on art or drawing as part of the

animation curriculum, I strongly encourage you to go outside of the program and take additional classes, in life drawing if nothing else. If needs be, just get a bunch of your fellow students and go out and draw whatever you see in the world about you. Even drawing other customers when you're drinking your coffee in Starbucks will go a long, long way in training your "animator's eye" – as well as showing a prospective employer that you never switch off your interest in life through a creative outlet.

If you are smart enough to include a drawing portfolio or sketchbook in any job interviews you may be part of, the work you show should include the right kind of drawings. In other words, anything that provides evidence of your knowledge anatomy, form, and dynamic pose is a good thing. Remember you will only have a limited amount of time to pitch yourself for the job in question so you need to make an instant impact. For this reason, I created a book for Routledge called, "The Animator's Sketchbook". It basically is a book with many blank pages for drawing in, each accompanied by a specific drawing assignment that is animation related. In other words, anyone who completes the sketchbook with their own work, and shows it in an interview situation, it will demonstrate to the recruiter that not only do you draw, but the drawings you have done underline also what you know about pose, gesture and other

animation principles in general. This I believe is an asset in a job interviewee's armory.

Quality over quantity:

Employers are tired of seeing big portfolios, packed with endless drawings that show just about everything you have ever done. They have little time to go through endless page after page of your work. So, be really discriminating with what you show them. My advice would be to have no more than 10-12 really good portfolio pieces to show, plus a tight but good showreel of animation, and a sketchbook if at all possible. If a recruiter wants to see more, you can direct them to your web, blog, or social media page – provided the latter looks professional and impressive however. Chances are, if you pass the portfolio/showreel/sketchbook test, then you are home and dry – or at least in the running!

Tailor your selections:

You should always tailor your portfolio or showreel to reflect the kind of job you are interviewing for, if possible. As said before, research the studio and try to ascertain what is their predominant style or approach. Screen your drawings, or any additional

illustrations or paintings you might also have, so that it represents your best traditional work, precisely targeting that studio in mind. Do similarly with your showreel, if possible. The broad shotgun effect - where you show just about everything you have, in the hope that something will stick in the mind of the employer, might very occasionally work – but usually doesn't, as they'll tend to remember the worst things or the things they hate the style of. So, if you have the depth of your work to narrow it down to only the areas you know they're most invested in, you will have a much great chance of making the desired impact.

Packaging is all-important:

A great deal of work reviews today are done remotely, so you will rarely meet the recruiters face-to-face, unless they invite you to do so. However, should you get a personal, face-to-face meeting – or if they ask you to send them material anyway – the following may help…

Portfolios, as well as your showreel packaging, should be attractive to look at, neat, clean, and styled in a way that best represents you, your design approach and your inherent personality. I once attended the Kalamazoo animation festival. There, I

heard that recruiters become very irritated if the work presented is dirty, dog-eared or sloppily designed. It says a lot about you and your standards, even if the work inside is impressive. This is very important when you are trying to 'brand' yourself with a stranger as someone who is professional, who is conscientious, and who has a pride in their work.

In my book "Pencils to Pixels: Classical Techniques for Digital Animators" (Focal Press) I talk about a conversation I had with artist, John Fountain, who spoke of his somewhat scary, yet utterly hilarious, experiences in getting started in the business. He also confided in some of the weird and wonderful portfolios he'd reviewed later, when established in a studio and interviewing applicants. The key thrust of his advice however was that you should always have a fun and memorable portfolio to look at. It should be one that is not 'too gimmicky' or 'too difficult' to review. It should not be too overflowing or disorganized with scruffy art and paperwork either. John added that studio wannabes should be quite selective in what they show, and to tailor the contents towards the job or organization that is being presented to. All great advice from the horse's mouth.

Finally, let's consider what major studios might look for when reviewing a graduate's animation reel…

First, there should be examples (in 2D or 3D, although these days it will usually be 3D) of good quality 'walk & run cycles', there should be 'idle movements if you're pitching to a game studio. All animation should show evidence of dynamic action, weight, timing, and acting. Dialogue is optional, although it would help if you have at least one good example of it. Today, evidence of fight action is desirable, or at least something that has two characters strongly interacting with each other physically. Obviously, student graduates are at the mercy of the college curriculum they have invested in. However, if much of the above is absent from your showreel of animation work, I recommend that you make it up by creating this material yourself, in your own time. However, just don't include it for the sake of including it, if it is not of a good standard. As I've said before, recruiters will remember most the bad work they see, not the good. I don't include anything that is not your best work. It is better to be light in terms of the above list, rather than have it all but it's not very good..

By contrast, let us now take a glimpse back to what the one-time great Disney animation studio required

of its old-school, hand-drawn 2D animation applicants. It will somehow underline how times have changed – although I would argue that the work they did then, in terms of character animation, is still far superior, across the board, to what is created today, regardless of our amazing technology! Anyway, sample portfolios were essentially required to include mainly drawings that showed a certain style and skills in the following areas:

Gesture drawings: These were required to demonstrate a feeling of life and movement. These kinds of gesture drawings would be undertaken in anything from 30-seconds to 5-minutes. They needed to indicate an awareness of 'movement' and of 'structural clarity'. They also needed to demonstrate the qualities of 'volume' and 'vitality' that can be captured in a drawn line. Such drawings could be from a life drawing class or from everyday observation. The studio hoped to see "spirited drawings that suggest character and attitude"

Sketchbook drawings: Applicants were expected to have kept a personal sketchbook, which would record observations from life and from the artist's imagination. They called these 'Café drawings'. These essentially were general sketched observations of people going about their everyday lives. They

were expected to show action poses of people in stores, on the beach, in the street or from their own homes. Sketches could be 'thumbnail' in nature or more fully developed compositional drawings.

Animal drawings: Portfolios were also expected to show drawings of animals in both movement and at rest. The drawings had to show an understanding of how animals move through space, their anatomy, and their structural volume.

Figure drawings: Recommendations were made for further explorations of the human form – clothed or naked – with a simple but clear examination of the unity of form and a more detailed examination of things like hands and feet. Dynamic movement sketches were expected to convey how a character moves and behaves. Body language in the pose was all-important.

Refined drawings: For further evidence of artistic skills, applicants were advised to show more developed drawings that included portraits, much more detailed hand and feet drawings in terms of the human figure. But also landscape composition or architectural representations were required. Drawings from photographs could be accepted but preference was always for drawings from life.

Effects drawings: Finally, applicants who were more interested in effects animation were also expected to show drawn representation of things such as dust, smoke, fire, water, splashes, explosions and/or lava. Sketches of things such as props, furniture and vehicles were also encourages where these were deemed relevant to the applicant's declared career path.

Clearly this required an exhausted and determined demonstration of an applicant's ability, depth of samples and artistic awareness. This all goes a long way to explaining why the quality of Disney art and animation was so high in those "Golden Era" days. Disney back then also offered an apprentice system that was second-to-none – as was the Disney studio back then. However, it should be noted that today, now the company is no longer superior to the others out there, they have no apprentice system anymore and there are hardly any positions available – at least in terms of a long-term, fixed contract basis. This is true of all the other big Hollywood studios too, of course. But even so, I would say that applicants for any jobs in the industry right now would be well advised to consider the above requirements for their own portfolios when applying for a position. The more accomplished the studio being applied to, the more conscientious the applicant has to be when

preparing and submitting their portfolio. You may not be able to present everything that the old Disney operation was looking for – but if you even get close to that, with quality work and drawings, they you will certainly raise eyebrows in a positive way with most recruiters. And what if you don't already have ANY of these sketchbook items to go along with your portfolio? Then keep on drawing until you do, as it will 100% support your more anticipated portfolio and showreel work.

And, speaking of showreels!

If you want to be an animator, the by far and away the most important element of your interview pitch must be your showreel. Whether you have it streamed online, you present your reel personally, or you mail it in in response to a job announcement - the contents of your showreel and the way it is presented will say everything about you. Remember, they say 'a picture is worth a thousand words"? Well, I would say that an animated picture is worth a million! You just can't neglect your showreel, ever! The better it looks, the better the work in it is, and even the better it is packaged, the more you will further your case in the long run.

There are a number of recommendations and requirements that you should consider when putting a reel together. Most of these have been gleaned from the industry itself, where I have questioned a significant number of animation professionals who are in a position to review applicant work and even hire successful candidates. So, taking heed of what what follows is something I strongly recommend!

Showreel length: One of the biggest errors that job seekers make when submitting a portfolio is to include just about everything they have ever produced, good or bad. As a result their showreel runs on and on. In this modern high-paced, digital world hirers just don't have time or patience to sit through ill-conceived reels that run on forever. Remember, the biggest studios get thousands of submissions a year. So, you can imagine the amount of their precious time that would be taken up if they watched every one of these showreels from beginning to end! Therefore, the loud and clear message must be here… 'keep it brief but make it good'! And, obviously in the light of this, never pad-out your reel just for the sake of it!

A consensus of opinions I've been told suggest that showreels should definitely be no more than 5-minutes long – and less, if possible. Ultimately, the

most important thing is to show your very best work that will turn heads, but not everything you've ever done. Employers are more accepting of seeing a short piece that is packed with animation excellence than endless repeats of mediocre or widely varying work. Ultimately, it is better to show 30-seconds of real 'gems', than many minutes of tedious, predictable action. That said, if you take the 30-second route, make sure that it really is stellar work, the quantity of which just cannot be ignored!

First 20 seconds: The BIG secret here that every job seeker should know is that, realistically, it's only the first 15-20 seconds of your animation reel that is most likely to be seen! This is the amount of time a prospective employer will decide whether they want to see more or not. Therefore, my strongest tip here is… ALWAYS PUT YOUR VERY BEST WORK AT THE FRONT - ALWAYS!

This means too that you don't clutter-up the first 20-seconds of your reel with color bars, titles, audio tricks or any other introductory material that is not your animation. Hit them between the eyes with your very best work and you'll have more chance that they'll want to keep watching an check out all your other work as well. Also, if you have something that hasn't been seen before, or have a secret

technique you have developed that looks really unique and good, put it at the front of your reel. I know of a graduate who got a fulltime job at Pixar, simply because he blew the recruiters away at an event portfolio review. It doesn't always happen of course, but in his case it did.

Professional level content: It goes without saying that the way you present your work says a lot about you as a professional-level artist. Therefore, make sure your reel is professionally presented and smart looking on every level. There should ideally be no sloppy editing or even annoying video glitches in what you show. An animation reel usually tends to be a collection of separate animation clips strung together with music, with smart editing to support it. But if the editing sloppily executed, it will entirely bring down the overall impression your reel gives, even if you actual animation is good.

Sometimes inexperienced job applicants think that really snappy titles and animated graphics up front will help sell their work. It usually doesn't work as recruiters are anxious to see your actual work but don't have time to wait for it to appear. Therefore, rather than add a whole number of sharp distractions, prior to what you want your audience to see, you should keep everything uncluttered, with

simply a name and a phone number superimposed in the corner of the screen. You can of course add some of your spectacular credits work to the end of your reel – although you need to hope that your animation work so impressed the recruiter that they will view it all the way to the end, anyway!

Essential animation content:

Now we come down to the real meat and gravy of your presentation – your actual animation content. Remember, you don't have to show everything you've ever animated. You simply have to bear in mind – as a result of your previous research - what the studio you are pitching to will probably be looking for. If, on the other hand, there is little indication of what a studio is looking for, you should hedge your bets and show material that will pretty much cover all eventualities, as long as it is all good.

The following is a suggestion of areas that might be covered when you show your work...

i) Core actions (especially for the games industry) - specifically walks, runs, jumps, idles, tumbles, deaths, etc.

ii) Other full body bipedal reactions.

iii) Facial actions - with or without lip sync.

iv) Quadruped actions – natural quadrupeds and/or fantasy beasts, etc.

v) Principle actions - with secondary actions and follow-through movement where necessary.

vi) Special effects animation – but only if you're interested in this kind of work.

Short film content: Because of the need to show initial impact and versatility, it might not be ideal to just show only a short film as your animation showreel presentation. You can show short excerpts, but I wouldn't necessarily show the whole thing – unless that is what they're looking for, or have asked you to present it, of course.

Character animation specifics: There are certain specifics that employers of character animators will be looking for in the applicant's showreel…

i) A demonstration of sound body mechanics.

ii) A sense of weight in character movement.

iii) Awareness of balance (i.e. a strong center of gravity in a character).

iv) Strong camera placement to enhance the action being featured.

v) Good physicality in acting.

vi) Solid acting (i.e. with strong body language and exhibiting real personality/performance qualities).

vii) Strong sense of observation in movement.

viii) Awareness of and ability in the twelve principles of animation as defined by Frank Thomas and Ollie Johnson.

5 GENERAL CONSIDERATIONS

You should aim no lower than "excellence".

I've said this before, but avoid bad work!

This is something I cannot possibly stress strongly enough. Never EVER show any work that is not your best! Even if you have some of the best work anyone has ever seen, it will be dragged down by anything that does not live up to it. A chain is only as strong as its weakest link, so make sure yours is strong. Not only will bad samples confirm to a recruiter that you are capable of doing substandard work, but it will also reveal to them that your

personal standards are not capable of editing out the bad from the good. Neither will help you when push comes to shove in the job market.

Adding the bad stuff also pads out an animation reel to something for more than it needs to, or should, be. As already stated, reviewers hate to sit through more than they possibly need to when searching for artists or animators. If they come across bad work before the good they will probably just hit the 'eject' button, before even giving themselves the chance to see anything better. This is the way of things in this modern, time-pressured age I'm afraid. If you are there in person, you should not be apologizing for what you're not happy with. If you need to do that, the signs are not good for a successful outcome. So, when you have something that's not up to scratch on your reel, be brave enough to eliminate it entirely. You won't regret it in the long run!

Be consistent with all your material:

Selling yourself and your work is all about strong and consistent, yes, 'branding'. This always should be reflected in everything you present. Reviewers will be looking for your talent and your creative process first and foremost. But they will also be looking to see if what you show them is consistent

throughout the entire material. These things are incredibly important when your work is competing with the work of anything between 20 to 100 of other applicants!

One man's beat is another man's poison:

Avoid loud and contentious music for your reel's audio track! Many inexperienced students tend to want to make a 'statement' by the music they choose to go with their work. They quite often evangelize for their favorite singer, band, or style of music. Beware in doing this, unless it is pretty mainstream. Even if your animation is really good, you might find that the person who is reviewing it absolutely hates your taste in music. It can go against you. They will instantly identify you as a 'type' they would rather not hang out with, or have to work alongside them. That's not to say you can use music. But again, research who you are pitching to and select something that you feel would be compatible with what they do.

If you must have music on your reel, keep it relatively safe and non-invasive. You might of course strike lucky and find someone who shares your own tastes. But the odds will probably be stacked against you – especially if there is a

significant age gap between you. You don't want to take the risk of missing out on a job you are applying for, solely based on musical taste. Perhaps when you're an established star Hollywood director, a major game producer and/or art director, you can maybe strike out with your own own way of doing things. But until that day, make sure that the image you project through the music you choose is not going to jeopardize your chances – especially if there is a tight decision between you and another candidate. If in doubt, don't use music at all. Let the quality of your animation alone speak for you!

Keep it light. Keep it positive!

Like your music tastes, your subject choices can be your downfall. For example, some animators like to work on the kind of dark and depressing subject matter that most people prefer to ignore. Others may like to create work that's bright, cute and charming. The rest will be somewhere in between – with a lot going for Anime! Just remember though, it is wiser to not show material that may be in conflict with the kind of work that the studio you're applying for does on an everyday basis. Never provide an opportunity to depress, or antagonize, or offend your viewer, especially if you want them to hire you!

Keep is short! Keep it smart!

I've said this before but I'll say it again until it sinks in - 'Brevity is the soul of wit!' If you show just one long piece of animation you are limiting the perception a reviewer has of you. A single longish piece of animation pigeonholes you in the minds of others. It's far better to show a varied collection of very short cameo pieces rather than that one long, meaningful film that probably is only really appealing to you, who lingered long and hard over its creation. Most film and game production today generally require a degree of versatility and flexibility in their creative team. Many job interviews are dedicated to finding the talented artists and animators who are flexible with their skills. Therefore, show a varied range of your best work as best you can. Show a short compilation of your short film if you must, but feature mostly a range of varied animation styles and actions to highlight your movement skills.

Be original:

Studios are of course looking for artists and animators who have all the basic skills. However, they become particularly excited when they find

applicants who have that little bit of extra technique, imagination or design vision that others do not have. What will therefore separate you from all the rest of the competition is if you can show the basic technical requirements that they're looking for - but do it in a way no one else has, or with a look they have never seen before. For example, if you are showing a walk cycle, maybe have you character walking on a unique style background. Or, if you have a bird flying, not only give it a remarkable wing action, but maybe set it in an environment that it would not normally be seen in.. There's more than one way to skin a cat, so its your challenge to make your work something that is different from the rest. You'll find some specific animation guidelines later in this book that should help you approach all this a little more insightfully.

Remember that, in this infinite world of the internet today, it is quite unlikely that you'll show recruiters something they haven't seen before. But try nevertheless. Certainly, in terms of student work, pretty much all the exercises and assignment work you show them will be pretty similar across the board to the recruiters viewing them. So, think outside the box. Sometimes, an individual will show up with a very different approach or style to all the norm of everyone else. They are the ones that get noticed and remembered!

Personal qualities:

There are three things that employers look for when considering a future employee. In addition to a high level of artistic talent, they need to possess an organized mind, a proven tenacity when the chips are down, and a significant passion for what they do. It is not easy to demonstrate all these three qualities at an interview, of course. But it should be possible to demonstrate the first and last ones, at least.

The good and the bad sides of student work:

Quite often all graduates have to show for themselves when they apply for a job are their regular school assignments. In general these tend to be somewhat underwhelming from a recruiters point of view, and pretty much everyone will more or less look the same. Hardly inspiring! Pushing the creative edge and showing a more advanced level of competence is something might like to add to their college work in their own time. It will be worth any time investment you make here, over and above the call of classroom duty.

Yet, don't despair. Sometimes, some school projects can show a great deal of positive things about the applicant, and that can certainly help them land the job. For example, most enlightened reviewers will recognize a well-finished student project, which may not necessarily be of top professional level standards, but is an indication that the student has discipline and they have tried to push their work beyond the acceptable norm. For example, they can show great creativity of design and storytelling – in addition to the actual animation - and that will show a commitment above and beyond. Certainly student work should demonstrate that the student can listen to instruction and carry it out successfully, but it can also indicate how they can think outside the box at the same time. Again, it's far better to show a little of your very best work than too much of your so-so or even bad work.

6 SUGGESTED ASSIGNMENTS

On occasions it desirable not to rely solely on the work you think worthy of showing in your showreel. Often the industry will have its own ideas on what they need to see and these things do change unexpectedly on a regular basis.

I'll say this again. You should regularly checkout what the industry needs at the time you plan to approach them with your work. When I was originally writing this, I asked a number of industry professionals – mainly in the games industry - what they thought first-time job applicants should show from an animation point of view. Here are some of their responses…

i) **Examples of 2D animation**: Although there are fewer and fewer jobs inside the industry for

traditional 2D animators these days, the smarter employers recognize that a knowledge of traditional 2D animation goes a long way to showing how well a candidate can really animate. With all the bells and whistles currently built into current day technology it's very easy for someone to cover-up a scant ability in animation with a multitude of effects and sophisticated rendering. 2D pencil-drawn tests tend to strip away all the distractions and show how well a character moves, or not. Therefore, adding some 2D work does a lot to convince a possible employer that the applicant really knows how to make things move well. It can also demonstrate an ability to draw consistently, if this is a quality the employer would appreciate.

ii) **5-10 seconds of lip sync**: This would need to include good body language, supportive facial expressions and of course, well timed and accurate lip movements. Nothing communicates a skill to get right under the skin of character-animated movement (i.e. with personality) than good dialogue animation.

iii) **Acting**: Strive to provide a genuine sample of some personality and performance in your animation. This really defines who is a real 'character animator' (i.e. one who can understand

physicality and emotion in movement) - rather than one who just makes things move with software.

v) **Show you know the software?** Software and technology changes in the blink of an eye these days. Therefore, it is really difficult for college students – and even their instructors – to keep up with those changes as quickly as everyone would hope. But recruiters do know this, so all they are looking for is competence with software and technology, no matter how basic or out-of-date it may be. Ultimately though, the industry needs animators first and technicians second, so they will be flexible if they think you have real talent but are not particularly software savvy. Therefore, if in doubt, focus more on improving your animated movement skills, rather than what buttons to push to make the latest software jump through hoops.

7 THE IDEAL COLLEGE

Whereas I don't in any way wish to undermine any school, teacher or program through the contents of this chapter I am becoming increasingly aware of the failings that animation students have when entering the job market. This is often because their education is not complete enough.

Now we get down to the real nitty-gritty of why you picked up this book and are reading it. Getting into the industry is one thing – but getting into a college first, that will get you into the industry, is another. Finding the right college to do that, for you is another challenge! This is where further research on your part is necessary, I'm afraid.

The complaint I regularly hear from colleagues and recruiters in the industry is often about the real lack of knowledge and ability that many student

graduates show when they are applying for their first job. This is sometimes the fault of student, but often, if can be the fault of the college. Some colleges are far out of touch with what the industry needs from their students – and sometimes the college is well informed but the instructor teaching the course is out of touch or doesn't really know the subject they are teaching. This is not true of all colleges of course, but it happens enough to make me think it's a problem. It therefore moved me into suggesting and ideal curriculum for what I think animators need to teach at schools. Now I would stress that this is not definite. It highlights my thinking at the time of writing. But, as we've already said, the software and the industry can change in the blink of an eye – so that was is desirable now, may not be desirable soon.

Academic program failings:

Ultimately, as I said at the very beginning of this book, the best learning in animation is by sitting at the shoulder of a master professional and taking in their knowledge first-hand, as an apprentice. Sadly those days are long gone and so the teachers in animation schools and colleges around the world should do their best to emulate that system – i.e. know your subject well, demonstrate it, then sit with

the student and mentor them until they get it. Now, this is not possible across the board, as class sizes can be huge in some colleges. But instructors should do their best to nurture their students, not talk at them.

It is commonly said - although not 100% accurately - "Those who can, do, and those who can't, teach!" The accreditation system in most countries universally require that full-time faculty have to have a degree in order to teach. This is totally understandable in science, engineering, medicine, math and a number of other mainstream subjects. However, in the arts – and specifically animation, which I know most about – it can be a significant handicap. It means that those degree-graduate artists and animators who can't make it in the industry turn to teaching to survive instead!

This is a self-defeating system. It effectively means that the worst candidates – i.e. the ones who can't get a job and have not industry experience – are the only ones allowed to teach students. Now, there are some teachers (like me, who has never needed a degree) who are passionate to teach anyway. But if you employ instructors who aren't even industry ready or honed, how can they offer good instruction to the students. It suggests that those students

themselves will probably not be taught well enough to get in the industry themselves – although they will be good enough to get a degree from their college. Then in turn, some of those will go on to teach - and so on and so on - diminishing the gene pool in the process!

I believe that this issue NEEDS to be addressed by the educational authorities one day soon, as the standards that apply to the academic subjects in education (such a math, physics, engineering and other similar subjects) are not in any way comparable to the needs of a more artistic community of students and educators. The result, the quality and knowledge of professional character animation these days is nowhere nearly as good as the animation that was done by previous generations, despite the significant development in the tools and technologies that are available to them. Again, we come back to the old issue of teaching traditional art skills before teaching modern technology. But that is an entirely other argument, best left for elsewhere.

How to discriminate:

Accepting that things are not perfect, I would like to offer suggestions to potential animation students on

things they might study – in and out of the system - in the hope that it will help them compliment their studies, should they be lacking at the school or college they are attending. There are of course some exceptional schools out there, although these are few and far between if the truth were known. Consequently, potential students, looking for a school of animation to enroll in, need to be informed enough to discriminate between what is good and what it not. So, here's one thought for you, along these lines…

Check out the faculty!

A college is only as good at the faculty that teach there! So, the very first thing an applicant should do is check the caliber of the faculty at that school they're considering applying to. Have they worked in the industry? What have they worked on recently? Can you talk to them, to see how they plan to teach the subject they are teaching? These are all valid questions. Some schools have a huge reputation, but actually have poor faculty on occasions – as the better faculty tend to be head-hunted by other schools who are offering better incentives and terms of employment. Other schools are pretty obscure in the greater scheme of things, and yet they have fantastic faculty from time to time. So, it is very

important to check these things out. Past reputations in schools and college mean nothing. It is what they are teaching now, and who is teaching the classes now, that is the relevant factor. Faculty move around more and more as they find better conditions and better opportunities. So, a college that was outstanding two years ago, because of their amazing faculty, may not be so now if those faculty members have moved on. It's best to check. If a school or college has nothing to hide, then they will tell you who is teaching and what they've done in the industry to prove their expertise!

You too are also part of the picture!

It is very important for prospective students to consider the school and the faculty under whom they will ultimately study. However, it is also very important to consider the other major component in the education process – YOU! Many students today attend school passively. This means they turn up expecting the teachers and the curriculum to do the work for them. They feel that as long as they show up on the first day of school, attend all the classes, get all their assignments done and turned in on time, they will have done all they need to do on their road to gainful employment. However if anyone genuinely wants to be part of the tough,

competitive, and yet ultimately extremely rewarding, industry out there, they need to put in much more than that – over and above the call of duty. Turning up in just body, minus mind, doesn't cut it. Turning up with an unquenchable spirit, as well as a tireless passion to succeed – even triumph – is much more important.

So, start as you mean to go on when you're finally in college. Don't just deliver okay work, even if your teacher things it's OK. Instead, go above and beyond, and deliver exceptional work that hopefully your teacher will rave about! Don't just work the required amount of hours on an assignment either. Work twice as long as you can, if necessary, getting it right and perfecting it as best you can! And don't just study the areas covered in the course curriculum alone. Go out and study additional related subjects! Things like painting, drawing, researching new software and techniques are good things to add to your studies, if they are not already there. You may be delivering exactly what your school required – and they may even celebrate you if you're doing better than expected. But the world beyond, in the industry, will be far more critical. So, invest in putting the work in while you can – because once you graduate there will be few opportunities to do so.

In doing this, trust me, your reputation will precede you. Many studios do regular checks on colleges, looking for exciting talents who might be coming through the ranks. You may even have employers calling you with work offers, rather than you calling them! So, trust me, the animation industry is a very small world, and word of things spread quickly. The worst thing you can do, therefore, is just coast through your school years. It may feel cool to be simply a student while you're there – and you might be tempted to accept any praise you get from your fellow cohort or even teachers – but I have seen many 'big fish in small pools" flounder when they find that they are indeed "small fish in a big pool" – out there in the wider industry world!

Between a rock and a hard place.

One item of importance that school advertising and promotional campaigns never tell you, is that even at the end of what could become an amazing time for you on your degree program, you may still be challenged to get a job because you just don't have that illusive 'industry experience' that most studios require! This, as I have said before, is a perennial problem - even for the finest students as the finest of animation schools. It of course raises the evergreen question that everyone is compelled to

ask 'How can I get a job if I don't have industry experience, but how can I get industry experience if I can't get a job?' To be honest, there is no easy answer to this. You will definitely find yourself between a rock and a hard place!

It is somewhat possible to slightly circumnavigate the problem, if you know of it up front. For example, in the past I've created a film or two that my students were able to work on as 'employees'. It was not a real professional production and therefore was not a perfect solution to the problem. But at least I ran it as close to a real production as I could get it, based on my decades of animation and production. So, my students did at least get a flavor of some kind in terms of industry experience – and they did get film credits when it was finished, which was great for their resumes.

Even better than this, some of the more established and accomplished schools can quite often include internship opportunities for their students in local studios. This effectively means that nearby studios are grateful to have help from talented youngsters during their crunch time - while the students in turn can claim to have gone through some kind of industry experience, no matter how short it may have been.

FYI: Internship opportunities for students are often the mark of a good school. It effectively means that a studio respects their students, and the faculty's teaching methods, enough to want the best of the students to work alongside their professional artists and animators. The studio of course benefits at the same time, as they can take advantage of these extra pairs of hands working on their productions for free, or if not free then for a very low nominal salary!

Educational program overview:

What follows in not a proposed program, nor does it pretend to be. What it suggests however is my overview of the kind of educational experiences and sequencing that I've learned from as a result of my own training, production experience and teaching successes that my students have clearly benefited from. They are mainly focused towards a full degree-level course in character animation, with a classical art and animation foundation. Not all schools will be able to embrace this core program of course, and I suspect some will not even value what I say here. But it does at least give potential students an idea of the kinds of things they should be looking for, when considering a school. If you're in a school that does not offer all these things, then try to go outside of the system and study them yourself…

YEAR 1:

Fundamental drawing.

Students will learn the basics of life drawing recording what they see from a live model - ideally with timed, dynamic pose emphasis. Assignments will incorporate shape, form, dimension, positive and negative space, etc.

Introduction to 2D animation.

Students will learn the basics of animation through drawing - walks, runs, jumps, squash & stretch, anticipation, etc.

Perspective and anatomy.

Students will learn the fundamental principles of both depth perception and dimension. They will also learn the basic elements of biped and quadruped musculature and skeletal structure.

History of Animation.

Students will learn the origins of animation, how it evolved and where it is in the current world market – covering WORLD animation, not just the tradition Hollywood based industry!

YEAR 2:

Gesture drawing.

Students will enhance their life drawing skills by working specifically with sequential poses and identifying dynamics and motion within a pose.

Advanced 2D animation.

Students will take the basic animation skills they developed in the 1st year and elevate them to the next level – investigating weight, balance and overlapping action through dance, drama and dialogue.

Character Design & Illustration.

Students will learn the process of character design, as well as drawing, illustration and painting techniques in a traditional and digital environment.

Storytelling & Scriptwriting.

Students will learn approaches to idea creation, scriptwriting and basic storytelling in traditional and contemporary terms.

YEAR 3:

Storyboarding & Animatics.

Students will begin to bring together all their previous skills in the creation of visual storytelling, which will be finally edited on screen and presented in real time playback.

Portfolio Animation.

Students will start to develop their animation portfolio pieces as defined and required by the industry at that particular moment in time. It would be desirable for industry professionals to review student work at this time and therefore identify areas where the students need to put a greater emphasis on the work they will show.

Concept Art, Graphic Design and Layout.

Students will learn the extremely important processes required in the visual preparation of the film, prior to animation. This will also include UI design for games production.

Producing Animation.

Students will be taken through the entire production process – Development, Pre-Production,

Production processes in both film and game environments.

YEAR 4:

Personal Film Project ~ and/or ~ Industry internship:

The culmination of three years of education can be demonstrated through a personal film project or by proving themselves by working with professional or group-based production activity.

Remember, these recommended core subjects are ones that I suggest will ideally prepare students well for their entry into the industry at large. 2D-centric students would also need to have digital animation classes too (2D & 3D), plus tutoring in the new AI revolution that is about to hit us at the time of writing. Throughout the latter part of the program ALL students should be encouraged to take advanced observational drawing classes, for project research, up to the point of final graduation.

Note: It is a popular impression that when you get in the industry you'll have much more time to 'do what you want' with your work, as opposed to what it is often thought of as limited or prescriptive

experience while at school. This is actually a myth. Working in the industry requires long, unpredictable hours that leave very little time (or energy) for any artist to do what they want, in their own time. Therefore, my advice to any student is that they should always take as much advantage of their classes - and any spare time outside their classes - to explore and experiment with new approaches to their work. It is, after all, a sacrifice of their valued free time – but one that will separate them from others, with their own ideas and styles outside of regular school work. (Making them look different when job hunting afterwards!) It's not a normal way of thinking for 'free at last' college students – but long-term planning is important!

8 ANIMATION WORKOUT

College is a time to learn, but it's also a great opportunity to explore additional things that will separate you from the herd.

What follows are a number of areas that are worthy of further attention when it comes to both animation and showreel content improvements. You may find that your course work is too overwhelming to deal with more. But if these things are not offered you, I would again recommend you going outside the system and learn them from other sources. It will pay you in the long run. Remember, employers are looking for graduates who are different from the rest. This could be such an opportunity…

Short film content:

If you're going to make a short film part of your showreel, don't make it more than 2-minutes long - unless it is unbelievably original. It's not as if studios will be reluctant to look at longer films in theory. It's just that they don't want to spend too long on any one person's work when wading through tens, or hundreds, of applicant showreels. Yet there is sometimes interest in someone who can make a good and attention-grabbing short film. (There's certainly no money in doing so, as there is not a short film production and/or distribution industry to speak of that will keep you alive solely by making short films!) That said, game studios do often need to create short theatrical-style sequences that work within a game play format. So, it will not hurt if you have something short and sweet along these lines to show them. But I emphasize… "short and sweet"! And remember, most showreel viewing decisions are made in the first 15 seconds for so. Therefore, make sure you hook them with great and powerful stuff up front, before revealing the short film side of your work!

Sometimes, very rarely, game cinematics can make use of dialogue and lip-sync animation. So, it doesn't hurt if you include short film, or other, material that

highlights your skills in dialogue animation. Studios are certainly open to looking at students who have a talent for animating dialogue. However, as I have said previously, recruiters rarely have time to sit through a long reel, waiting to find your dialogue piece. A very short, well animated, dialogue clip might open up your showreel quite imaginatively, if you plan it that way however.

Don't however neglect to add a link, somewhere in your presentation, that can take recruiters to a larger form of your portfolio and/or showreel online. Recruiters may just show interest in your reel – enough to want to see more. So, the link will solve that. Therefore, give them a simple option to do so if you can. And anyway, I have known more than one student who has been discovered on YouTube or Vimeo and given a job opportunities as a result! So, having a solid presentation of your work 'out there' cannot hurt anyway.

Note: Most of the emphasis here has been with regards job interview opportunities. However, in terms of animation, having an internet presence with your work could attract other interest! For example, advertising agencies are always on the lookout of bright and new talent to build certain commercials around. So, they tend to jump on

something that is new and refreshing – and student work can often be that.

Acting classes?

I always suggest to students that they should enlist themselves into the *'method'* school of animation. What I mean by this is that if they are to animate dance or drama in animation, for example, they should explore dance and drama in their own bodies. It may be a very tough challenge for them to dance like someone on "Dancing with the Stars". However, by observing dancers - and even trying the moves out for themselves - they will get a better *feel* for the kind of animation they're attempting.

I was once a serious track & field athlete – with all the varied training that this entailed. So, I found that in having the 'muscle memory' from all that physical activity in my past, it now makes me a very good 'action' animator – meaning that I find things like runs, walks, jumps, throws, etc., etc., much easier to animate than, say, 'dialogue', where I've never had any experience of acting at all.

And with dialogue animation specifically in mind, I would suggest that enrolling in acting classes would

most definitely give you a greater sense of performance and dramatic characterization for when you're animating a character delivering words. Most acting classes should not be too much of an expensive investment for you - depending on where and what level you take them of course. But they could be a wise investment, in terms of you becoming a better character animator – even if you take those classes for one term at a local community college, or amateur dramatic group. It has long been said that animators are actually frustrated, or shy, actors anyway. So why not take the plunge and get a feel of what great dramatic performance is all about. Your work – and therefore your chances of landing a job - could totally benefit from it!

Gesture, flow, rhythm and anatomy work.

Anything that a student animator can do, to better demonstrate well-timed, flowing movement in their work, will get them further up the hiring ladder. As we have suggested, 'acting' is a good ability to have, although that will often mean very little in the world of games animation, should that be your objective. It is more in theatrical based filmmaking that acting skills will necessary.

Beyond animation acting skills – but not excluding it either - I would strongly recommend that students use a long mirror to study themselves acting our a particular action they are planning to do. Even better of course, employ digital camera on your phone, to capture you acting out a performance before animating it. That way you can play it back, repeatedly, until you replicate it in its animated form. This is what all the top animators do anyway. Nothing is just made up in the head and animated without reference. Remember too that animation is an *exaggeration* of reality, not a direct copy of it. So, as you define your key poses from your reference material, whatever it may be, push and extend your poses to make them more dynamic and powerful. Your animation will look more natural as a result, strangely enough.

What you are principally looking for with your animation work, even at the college level, is good 'gesture', 'pose', 'attitude', 'expression', 'timing', 'spacing', 'balance' and a general overall 'flow' to the action. If you can do this in one single piece of animation, then definitely do it. With other things you might attempt – i.e. 'performance' animation. or 'dialogue' – remember that it will take much time and experience to perfect that action. Never settle for the first thing you do, as it will show. So, don't be too ambitious in what you are attempting. At this

stage you have limited time and limited experience to pull the great things off. So, be less ambitious with your subject-matter - just make it really, really good, however humble your subject choices may be for your showreel work.

Drawing from life, with both clothed and naked models, will always add to your appreciation of 'gesture', 'geometry' and 'anatomy' in your work - as well as improve the general flow to the dynamics of each of your poses. So many animators have attested to the benefits that extensive life drawing has brought to their work – and this is whether they are traditional 2D animators, 3D animators, Stop-frame animators, or Claymation animators. It is simply the process of observing, recording and understanding what you see that is the benefit here. Training your 'animator's eye' is extremely important and figure and gesture drawing is the key to improving this. Life drawing can also incredibly relaxing too, after you've spent hours and hours, peering mindlessly into a glaring computer screen or 2D animation lightbox, struggling to get your animation right!

Portfolio feedback:

One final piece of advice. Do not be afraid to show your reel and portfolio to others, for feedback and advice. Of course, choose only those individuals you will respect for an opinion. If you can find seasoned individuals to do this, take advantage of their advice. Sometimes we are so close to our own work that we cannot be totally objective and see what is obvious to others. Detailed feedback can be a roadmap that guides your through your chosen career path, providing direction and signposts that can be very valuable to you.

Yes, there are online forums that allow you to post your work for critique and feedback, but beware that too much uniformed feedback does not mislead or depress you if it is negative. Certainly, don't ask your family for their thoughts – as they will either be too afraid to hurt your feelings, or they might be overly critical, if we're factoring in sibling rivalry here! The advice of one who knows - however brutal or honest it may be - is far more valuable to you than the praise of an army of well-wishers. So, choose your advisers wisely!

9 A FOOT IN THE DOOR

Showcasing Your Work:

Next let's explore the notion that although we have the most incredible portfolio or showreel to present, if no one gets to see it then we'll have a snowball in hell's chance to land a job in the animation industry. So, let's consider ways of getting your name and your work out there...

Finding the Jobs:

First and foremost, it cannot be reiterated enough that animation is NOT a reliable, lifelong career choice for anyone! Never fool yourself, or others, into believing that. The animation industry, like film and theater, is a transitional beast that tends to ebb and flow, wax and wane, quite regularly. The work is contract based too, as we've said – meaning you'll be hired for a fixed time on a production, then once it's over, you're looking for the next job again. Rarely, very rarely, will you ever find a fixed, 'nine till five' kind of job – unless you are extremely lucky.

You should therefore accept this fact of life from the beginning. You're dealing with a mercurial beast here, where in all but the very few jobs at the top of a big studio circus, you might well be spending more time seeking work than you are doing it! This industry is getting more and more like the other areas of the entertainment world, where animators are like actors who have to interview/audition for new jobs on a production-by-production basis, then they move on to the next. Consequently, you always have be vigilant for new work that's popping up, and keep your fingers crossed that lady luck is with you when you apply. Networking and experience

helps of course, but sometimes it's just in the lap of the animation gods.

Learn to be patient.

It is very important that you learn to be very patient when seeking a job - especially that first job. I have known some mediocre graduates get a job in the blink of an eyes, whereas extremely talented ones have taken weeks, months, or even a year to get that perfect, first entry position! There is no golden rule to this process, and sometimes it throws up the most delightful, or depressing, of surprises. One former student told me that it took them about 3 weeks to see <u>ANY</u> responses from their first round of applications, four weeks to land a first interview and then two further months before they were offered their first job. This I would say is pretty much par for the course - with a few students succeeding faster than that, but most succeeding far more slowly.

The reality check - and reminders:

Another thing to realize in the animation world is that a great deal of its personnel are out of work at the same time. Jobs come and go and contracts

begin and end. Usually a large number of people will be out of work at the same time, as they are all laid off within that same time scale. If you time it badly, then you will find that the odds against you getting that first-time job are really stacked against you. You could even be better than those you are competing with, but as they are already in the business and have *'industry experience'* built-in, it could well be that they are favored over you. It's not fair, but that's often the way it is – so patience is required if you are to keep your sanity, and your confidence, intact.

So, never daunted, repeatedly seek out industry events and plan your assault on the studios coolly and calmly. Research the way things are and time your approach for when projects and jobs are on an upswing. And of course, don't neglect the internet for job postings, showreel or portfolio reviews, and even pitch yourself for client work. It may be that you're not designing to be a studio worker. But, if you have a lot of talent and style to offer, you might find becoming an independent contractor, or studio, is a better route for you. Your social media postings can give you a great deal of traction too – especially if it's high quality and original.

It is also important to be vigilant when you have a job and can see the eventual end of your contract

approaching. To beat the competition you need to plan an exit strategy early, so that you'll hopefully have the next job lined up BEFORE the current one ends. Even then, you just can never predict when things might take a change for the better, or worse, even if you have a contract position signed and sealed for a date sometime in the future. Some of the smaller studios have been known to close unexpectedly. So, it always helps if you keep your ear to the ground to see what your next option could be, should the 'if' moment happen. In times of peace, always prepare for war!

Networking:

Remember first and foremost that, although it is a world-wide phenomenon, animation is very much a small world in many ways. So, most crucial to the whole process is 'networking'. If you don't know, or haven't developed, contacts in the industry then you definitely won't hear about job opportunities on the grapevine! Many jobs are acquired by artists and animators being 'in the know', long before anyone else. This most usually happens by someone you know tipping you off once they hear something - or by you just bumping into the right person at the right time. Yes, usually jobs are announced – but on many occasions after they have already been filled!

Studios need to go through the formalities of advertising, but quite regularly they have already got someone in mind or signed. It's often like this because employers in some places are legally required to go through the process of advertising for a position, even though the job is filled on a 'nod and a wink' basis. Again, it's unfair, but that's how it works with some companies. Even more reason therefore to build your network of contacts as soon as you can.

Job-hunting can also become a quite nomadic form of existence too – that is, if you are able to do it. Animated TV, Film and Game productions are springing up pretty all around the world these days – as well as remotely on the internet - so if you want to break into the world-wide industry, you have to seriously consider packing your bags at a moment's notice, if that is something that works for you. India and China especially have developed significant animation industries over recent years, and – politics apart - but are still looking for Western expertise to train their own workers and/or students.

Occasionally, representatives from the bigger studios will appear at festivals and conventions – such as the "Lightbox Expo" and 'CTN Expo' in the US – and there you'll often find portfolio review

sessions to show your work at. This should definitely help you find the chance to meet with the big boys on their own patch and pitch your work accordingly. You'll also be able to rub shoulders with many other artists and animators in more distant parts of the industry – mainstream and indie. Again, this will provide more excellent opportunities where you can make contact, get feedback for your work and build networking opportunities for yourself. There are of course many other small festivals, events and Comicons out there, where you could have opportunities to do this too. So, stay vigilant.

Cold calling:

Sometimes, if you just can't find job advertisements, or friends in your personal network offer no leads, there's always 'cold calling'. Cold calling means you effectively get out there and trudge the streets, knocking on the doors of the studios unannounced, until you can possibly sniff-out a good job opportunity for yourself. It sometimes sounds scary and is pretty hit and miss but on very rare occasions you can really strike gold! Let me give you an example…

When I had my own studio in London and was preparing to start production on a 26-minute TV Special - called "Cathedral", and based on the book of the same name by David Macaulay - I came up against a particularly difficult problem. I had assembled a great new team of artists and animators for the production, but I was in desperate need of a specialist artist could conceive and design 13th century French gothic cathedrals! Now it is very unlikely in this day and age that an artist like this was even in existence, let alone available! Yet we tried. We used all our regular contacts to find such a person. However, alas, our search was in vain. But then, a week before the production was about to officially begin, we had a knock on the door of the studio and a young Polish guy, Darek Gogol, walked in with a huge portfolio under his arm. In a very, very broken English way he explained that he'd just arrived in the country, having flown speculatively in from Poland. He was looking for a job. We told him we basically had an art and animation team in place, but we added that we were in desperate need of an artist with experience of 13th century architectural drawings. He immediately pulled open his portfolio and produced endless (and exceptional) illustrations of both old cathedrals and medieval castles! Needless to say we hired him on the spot and he became one of the stars in our production!

But, Darek's story didn't end there. After about 9-months work on 'Cathedral' we had to downsize the studio and sadly needed to let him go – as is usual in the industry. He was actually OK about it, as he again explained that he'd already decided to try his luck in Hollywood. So, leaving us, he jumped on a plane to Los Angeles and again went cold calling around the big studios - totally unannounced. One of the studios he went to was Disney. Now, most people don't even get near the front door without an appointment. But, somehow, Darek managed to get to show his work to some of the folks there, as he'd done with us. As a result, he was promptly hired again! You might wonder why, as we did when he told us. Well, it seems that they were just about to start "The Hunchback of Notre Dame" production and were in desperate needed of artists who could paint cathedral backgrounds! So, as he'd just finished our cathedral film, he'd landed on his feet in another! He's since carved-out for himself a leading, in-demand, creative director role in the Hollywood industry – all of which proves, most emphatically, that being in the right place, at the right time, can be the greatest opportunity you have. You just must be ready for it and have great work to show.

Now, of course, Darek's story will not work like that for everyone. However, the message is loud and clear - if you don't ask you don't get!

Tip: Never say you're desperately looking for work when you're cold calling. One thing to say is that you are excited with the work you have and want to show it to someone, as you think its something that people will want. Saying you need work will insure you'll appear desperate - and therefore perhaps unemployable in the recruiter's mind. But, if studios think you've got something that no one else has, or you're really excited by what you do and want to prove what you can do for them, then they might just let you in to try you out. If you have a contact at another studio, or a mutual friend that's working in their studio, then definitely state that as part of your introduction. This may get you in a little more easily.

Recruitment Officers:

Although most job seekers will apply for advertised positions via a studio's HR or Recruitment Office it is widely known that not many people actually get their job this way! It is again a question of networking, of 'who' you know not 'what' you know. Although many jobs specify that they want animators with degrees from schools or colleges it is

not uncommon for most animators in a studio, at least up until recent times, not to have a degree in their chosen subject! Certainly most of the senior artists and animators in major studios have worked their way up through the company – with some of them probably coming as graduates in the first place. This is not just my own experience, but many industry professionals, from all aspects of the industry, have all agreed that it is ultimately the quality of the work in your portfolio, or showreel, that will get you the job - not the piece of degree-based paper you have in your hand! But all studios are different, so that's not a statement to take literally!

The Right Stuff:

Let's now talk briefly about personal attributes for a minute. If you really want to work in the animation industry, and are committed to doing so, then you need to have the right stuff to make it and continue making it. The primary qualities you need to develop include those of 'persistence', 'passion' and 'tireless determination'. For some individuals it will all go like clockwork. They will knock at the doors of the industry and, like Darek, will somehow walk straight into the perfect job. It is not the norm, but it does happen. Therefore, if someone around you manages

that and you're still struggling, then don't hold it against him or her. Nor should you let it dampen your own commitment, because the cream always rises to the surface in the end.

Of course you do have to add 'talent' to the mix - as without it, you'll really find the going tough. That's why, as a student – or even as an intended student - you have to work hard at what you're doing and make it count. The usual four-year program that most schools offer may seem a long time when you're facing it - and with so many distractions along the way, you could be deflected from your path. Yet, you must always try to remain steadfast and determined in what you want to do - and never forget the outcome you want to achieve. Think of school like a boot camp if you like, where you'll learn by pushing yourself through hard and persistent effort, to develop the work and personal qualities that will bring you those industry rewards in the end.

And remember, if it turns out that you're not one of the lucky ones, that land on their employment feet immediately after graduation, then you should begin to condition yourself now. And, if the program you are in turns out not to be perfectly suited for training you will need for the animation world

you're aiming to join, use your spare time to extend your skill-sets to accommodate that. Recruiters can often sniff-out the right stuff when they see it - even if the person their considering is not fully equipped to show all the work skills required. This could mean that they could well still take a chance on you if they like you. So, develop a passion to learn from the very start of your journey, and make it your second nature when it comes to interviews. This could ensure that you win through in the end.

Self-preservation:

Next a quick piece of advice about self-preservation. The animation industry is a small world, so always be smart about the way you conduct yourself in it. For example, never be too publicly critical about a particular studio's work or personnel. Gossip - good or bad - travels like wildfire, especially through social networking. If you're overly critical of other studios, or individuals in those studios, then you can be sure that you will be found out. Therefore, there will be little chance of you getting a job there in the future. (And remember comments posted on social networks can live forever.) Most studios are very proud of their work, be it actually good or bad, so they will be very defensive if you're seen to be attacking them.

Similarly, if you are rejected for a position in a studio, don't be moody or mad that you didn't get the job. Be mature in the way you deal with the people who you have to communicate with as, even if you are talking to the office gofer who might one day rise to a major power position in the company and make hiring or firing decisions. You can be sure anyone that what you say when you return will get to the people who do make those decisions. Consequently, if you behave badly you will most likely never be asked to come back to interview again. Alternatively, if you were mature and respectful, that will go down as a good thing in your favor with a distinct possibility that you will be remembered when jobs come up in the future.

Self-deportment:

In addition to having a good portfolio or showreel and preparing yourself psychologically for the jobs searches ahead, you should also make sure you are prepared for the one-on-one interviews you may get if a studio is interested in your work. When you do get your foot in the door and have that all-important first interview, and beyond, make sure that you respect the basic rules of etiquette.

Never be late for an interview. Give yourself plenty of time to be at the meeting if necessary as punctuality is extremely important when first impressions are built up. Then when you turn up always, always be respectful and courteous in your manner. Even if you want to appear 'cool' and the studio you're being interviewed at has a laid-back and cool reputation itself, you should never be sloppily, dirty or in any way overtly eccentric in your appearance. Casual is fine, but there is a point of scruffiness, or weirdness, that just does not cut it. Remember that regardless of their image, or reputation, prospective employers still look for solid, likeable and reliable employees. Consequently, if you present yourself unwisely you will inevitably run the risk of undermining their confidence in you.

Remember also to have a good attitude when presenting your work. Above all else, be passionate! Passion shows you are sincere about your work and that you care about what you do. The worst thing you can do is come across as indifferent, fashionably cool, or simply superior or disinterested - as this will significantly antagonize the very people you hope will give you what you want. Listen and absorb. Never argue, or become sulky, or close your mind to options that present themselves. Once you're in, even at the lowest of levels, you can work your way up the chain and prove your worth in time. It will

also enable you to build-up the 'industry experience' which is gold dust for all future employment elsewhere. Absorb and learn, then go away and reflect on how you can improve your next presentation if this one goes against you.

Remember, like animation itself, you'll only get out of an opportunity in direct proportion to what you put into it. It therefore makes perfect sense to continually upgrade and evolve your presentation material as you get more and more feedback along your way. Even if that first job offer eludes you, spend all your free time in creating new animation, new drawings, new designs, new illustrations and new whatever you need to round out and upgrade your portfolio or showreel. Studios like to see progress and they like to see that you're constantly involved with the industry – especially if you visit them for another interview, for another job, later. Just never give up – as, in the end, you'll ultimately be well rewarded for all your efforts in time.

10 PERSONAL BRANDING

With any profession – especially a creative industry profession like animation - it is vitally important that you brand yourself in any way you can. Even if an interview does not go well, you should leave behind a good impression of yourself, if nothing else – as well as tangible evidence of your visit. Therefore you need to consider things like business cards, resumes, and website and/or social media links to remind others of your existence.

Business Cards:

The business card can be the biggest ally you'll have to noticed when networking. You just never know when you might meet that one all-important right person at the right time. So, you'll need to be

prepared for that eventuality. Usually when you meet someone who is important to your dream, you will neither have your portfolio or your animation showreel with you. However, if you have a slick-looking, well-designed, business card with you, you can easily hand it to them when you introduce yourself. Business cards are small, inexpensive and extremely portable. But they can contain all the important information that others can follow up on. We mean by this your phone number, your email address, maybe your social media URL, and most definitely your website or page, where all your work can be viewed at the click of a button. And all this can fit on the card that you have in your pocket. So, there really is no reason why you can't be prepared for any chance, unscheduled meeting that could crop up unexpectedly.

Dog-eared, tacky or poorly designed business cards however will definitely not leave a good impression with the other person if you do it that way. So, definitely spend a great deal of time and thought on what your business cards looks like and how clean you keep them. Anything you show to someone else, speaks a great deal about you. So, make sure your business card does the job it's intended to.

Resume:

The next thing you must focus on, in terms of personal branding, is your 'resume', 'bio' or 'CV'. (They are all the same thing to be honest. They're just called different names is different places – although we'll use 'resume' for the sake of clarification and simplicity here.) For better or worse, your resume will be the clincher that helps, in a big way, to get you that all-important interview or job! Your resume will either be very impressive - if you've been in the industry for some time and done a lot of things - or else it will be pretty thin, if you are a student looking for their first-time job. There is probably not very much you can do about the latter to be honest. But, if you've worked hard at everything we've talked about so far, you should still be able to list some things you've done, that might catch the eye.

For example, if you were president of your student union, this might be something that will appeal to them, if they are looking for someone with some degree of leadership potential. 'Soft skills' like this are what can often separate one candidate from another. So be sure to include anything in your resume that may give you that added advantage! If you created the poster for the school's annual dance,

or the graduation exhibition, or other social event, then definitely include mention of it. Anything responsible that you have done at school, or outside school, could well reflect something they might be looking for. I have seen one major animation studio employ a certain film cameraman in their story department - simply because visual storytelling is as important to them as written storytelling! It is not acceptable to make things up of course. But, as long as you can eventually back-up your resume claims with evidence, you definitely should include them.

Technically, the resume is usually a simple, bulleted document that clearly lists everything you have done or achieved throughout your previous career. Often, it is required to be all on a single page, although professionals with a strong track record find this hard to do. The resume should not be a verbose, flowing document of detailed prose. Instead, it should be more a simple and concise listing of the key things you have done or know. A recruiter will use your resume to propose you for an interview or a job, so they will definitely check it all up of they thing what it contains puts you in the running. However, if some of what you say cannot be verified, then any trust they have in you will be lost and your resume will probably end up in their trash can. They may also may ask you for references in

relation to what's in your resume. So, prepare to be able to do that too.

Traditionally a formal resume should cover three areas of information: your 'skill-set', your 'knowledge base' and if possible, your 'previous work experience'. Ideally, as I say, this all should be contained on one page. But, if your experience and credentials are extensive, then I believe it is okay to go beyond that one page if your career record justifis it. Anything beyond two pages however might just start to test the reader's patience.

Listed experience can amount to two things: "job experience," where you list all the previous jobs you have had (if any?) or else "software experience," where you list all the major digital applications you are most experienced. The first is hard for the first time job-seeking student to complete of course, although if you had any INTERNSHIP experience during your student years you should most definitely include that! The second category is a lot easier for the first timer to include. As a student graduate you may still be competent and accomplished in a number of standard software applications that the industry is using. All that said, still don't limit your skill-set list to just software applications, as many jobs in the animation arena require other significant

qualifications and experiences too. Capabilities such as 'life drawing', 'painting' (traditional techniques and/or digital), 'concept art', 'sculpture', 'character design', 'cartooning', 'storyboarding', etc. may also attract the eye of a prospective employer. However, never fabricate skills - or qualifications – as the worst thing that could happen would be for them to ask you to demonstrate your skill in any one thing on the spot! Again, being caught out with this will lose immediate trust and your resume would end up in their garbage can!

11 FINAL THOUGHTS

With the book, I've tried to give the best of my knowledge and advice, born of a career journey of many decades. In that time, so much has changed. So much so that what was true at one point in my career was not so soon after. Similarly with the material covered in this book. At the time of writing, in late 2023, we are on the verge of an AI tsunami, which threatens to change everything, inside and outside of the industry! Consequently, what it true now may not be true in a year or two.

However, all I can honestly do is give you my best advice with the situation as I know it now. Even with AI entirely changing the landscape, I do wholeheartedly believe that traditional art and animation skills, working with the new technologies, will place you way ahead of the field. That's why I constantly champion what I do here. Technology is ultimately only as good as the person who is operating it. Consequently, if you are a traditionally trained artist or animator, you will bring so much more to the party than a technician. I therefore urge you to always be an artist first, and a software operative second.

Tony White and the 2D ACADEMY

Tony White is one of the most respected animators/teachers in the world today. He also teaches and mentors young students through his *"Starmaker"* mentoring program at the 2D Academy. Both prepare students well for college and for the industry. An award-winning professional animator for over 50 years now, Tony has apprenticed many professional animators and students. To date, Tony has made over 200 TV commercials, 2 TV Specials, several Short Films (one of which won a British Academy Award) and conceived, directed, and animated the award-winning title sequence for "The Pink Panther Strikes Again" movie, for the Richard Williams studio, during in his early London days. Tony was himself apprenticed by 3 of the greatest animators of all-time - **Ken Harris** *(Warner Brothers)*, **Art Babbit** *(Disney)* and **Richard Williams** *(3-times Oscar winner)* - and has evolved what he was learned then throughout his own 50+ years of industry experience. Tony now develops his own projects, as well as giving back his knowledge and experience to the student animators of today and tomorrow - through his books and his online 2D ACADEMY school.

www.artstation.com/tonymation

www.2dacademy.com

Tony's books:

Many of Tony White's animation books are used as standard textbooks in schools and college around the world. Here are the ones published so far...

'THE ANIMATOR'S WORKBOOK': (1978)
(Currently out of print) ISBN-10 0823002284

'ANIMATION ~ FROM PENCILS TO PIXELS': (2006) ISBN-13 978-0240806709

'HOW TO MAKE ANIMATED FILMS': (2013)
ISBN-13 978-0240810331

'THE ANIMATOR'S NOTEBOOK': (2011)
ISBN-13 978-0240813073

'THE ANIMATOR'S SKETCHBOOK': (2016)
ISBN-13 978-1498774017

'ANIMATION MASTERCLASSES ~ FROM PENCILS TO PIXELS': (2022) ISBN-13 978-1032345864

Printed in Great Britain
by Amazon